THE JOY OF MOUNTAINS

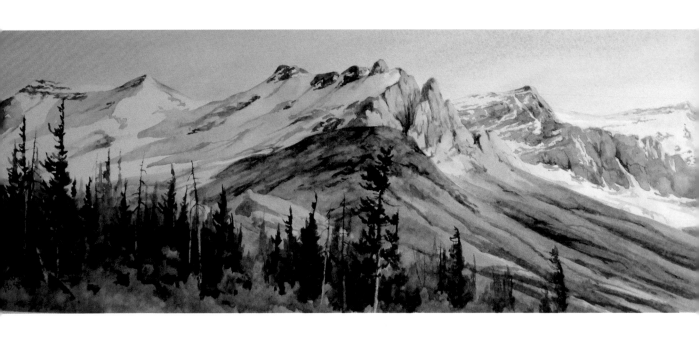

The Joy of Mountains

*A Step-by-Step Guide to Watercolour Painting
and Drawing in the Mountain Landscape*

⟫⟫⟫ VOLUME 2 ⟪⟪⟪

DONNA JO MASSIE

RMB

RMB | Rocky Mountain Books Ltd.
rmbooks.com
@rmbooks
facebook.com/rmbooks

Cataloguing data available from Library and Archives Canada
ISBN 9781771601641 (hardcover)

Frontispiece: *Mt. Athabasca*

The author and publishers of this book gratefully acknowledge the generous support of the estate of Nell Whellams in the completion of this project. Ms. Whellams was a longtime member of the Alpine Club of Canada and a committed mountaineer. We hope this celebration of the beauty of high places captures her own love for the mountain world.

Printed and bound in Canada by Friesens

Distributed in Canada by Heritage Group Distribution and in the U.S. by Publishers Group West

For information on purchasing bulk quantities of this book, or to obtain media excerpts or invite the author to speak at an event, please visit rmbooks.com and select the "Contact Us" tab.

RMB | Rocky Mountain Books is dedicated to the environment and committed to reducing the destruction of old-growth forests. Our books are produced with respect for the future and consideration for the past.

We acknowledge the financial support of the Government of Canada through the Canada Book Fund and the Canada Council for the Arts, and of the province of British Columbia through the British Columbia Arts Council and the Book Publishing Tax Credit.

This book is dedicated to
Maude Cathey Massie
and
Dorothy Bowman Franklin

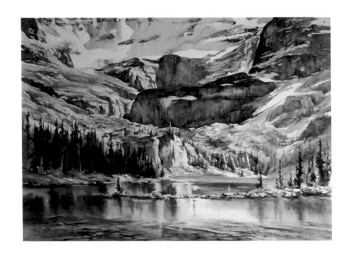

Sargent's Point, Lake O'Hara

Contents

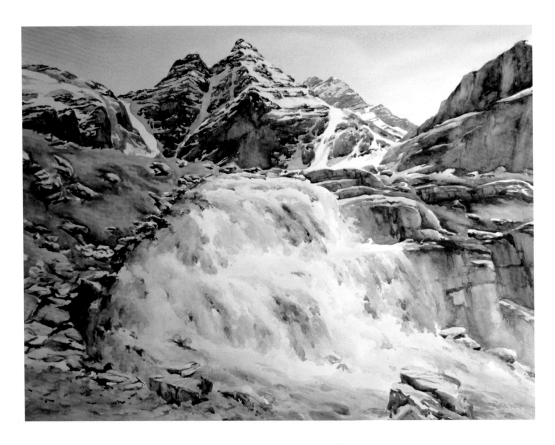

Victoria Falls, Lake Oesa Trail

Acknowledgments

In the 27 years that I have been teaching art to adults and youth, I feel that my world has expanded through the people that I have met and the friendships that have developed. I have 50 students in the three classes that meet in the fall, winter and spring for seven weeks. Their encouragement, enthusiasm and good nature has been invaluable. This book would not have been possible without members of the Thursday Morning Advanced Class who willingly tested pages and made valuable comments. You see, an art book is a bit like a cook book in that you have to test the directions! And in this book, each page was tested, usually more than once. Thank you to Janet Amy, Sylvia Hayes, Carole Garland, Theresa Maxwell, Cliff Swanlund, Danni Perkins, Sue Bolter, John Fisher, Marilyn Willox, Doris Leavitt, Joan Saunders, Annette Wichmann, Margaret Dodd, Shawn Fedora and Sheila Churchill.

Thanks to Ron Chamney for his geology expertise, Suzan Chamney for always being there to answer my questions and Joel Christensen for sharing his knowledge of biology and exploring the mountains with me.

Rocky Mountain books was extremely helpful throughout the publishing process. Thanks to Don Gorman, Rick Wood, Chyla Cardinal and Cory Manning.

My son, Clay, has used his technical skills to answer questions and solve my computer problems. He has been steadfast in his support and shares my love of hiking and the mountains.

Introduction

During the past ten years, I have taught workshops for many diverse groups and corporations — the Calgary Zoo, the Alpine Club of Canada, the Whyte Museum, and Alberta Foundation for the Arts — as well as ongoing adult classes in Canmore. I have worked with students aged six to 86, and I have learned as much as I have taught. I would like to share some of the things I have learned about art, people and this thing called "creativity."

In this book, I explain the basics of watercolour painting and sketching in a series of step-by-step demonstrations, and I list the supplies for a beginning watercolour painter. You will also gain an appreciation for this medium as you see how a painting/sketch is "made." However, in order to learn anything, there is something absolutely essential: you must relax and have fun!

I am convinced that art is teachable and learnable.

There is not an "art gene" that some people have and others missed.

It has always amazed me that people seem to think they should enter a workshop, sit down and automatically create a finished product. Yet, these same people wouldn't expect to sit down at a piano and play with no instructions! So it is with painting — you have to learn the basic skills and then practise, practise, practise.

More recently, I have formed the opinion that creativity is an essential human need. One of the first things humans did — besides making stone tools, hunting and gathering — was to dip their hands in earthen pigments and make images on cave walls. Art is, quite simply, the domain of all people.

After you read through a section, venture out into the mountains or simply look out your window and create your own unique watercolour sketch.

My passion is painting. I'm happiest with a paintbrush in my hand. May you catch some of the creative spirit and passion as you make your own sketches!

Maps

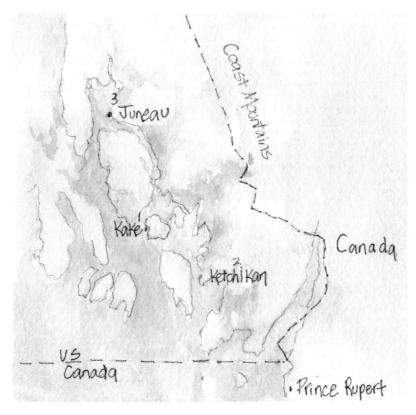

Alaska, Inside Passage

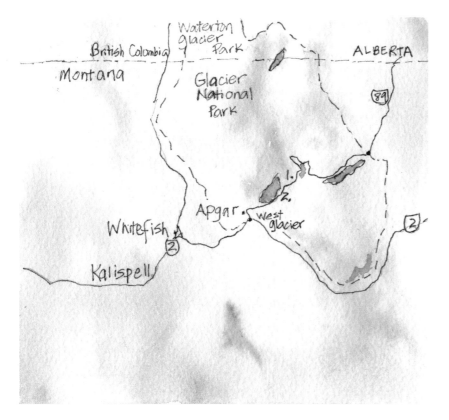

Glacier National Park

American Southwest

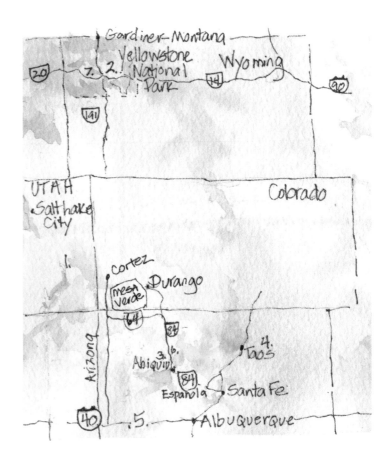

Canadian Rockies

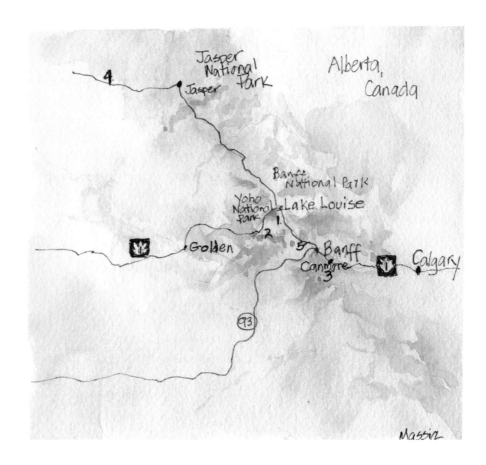

Sketchbooks

Well, I have a confession – I am a sketchbook addict!

Every time I see a new one – with a different cover, colour, material, or perhaps a ribbon to tie it up – I have to have it. Consequently, I have numerous sketchbooks; in some of these I only painted two or three pages before I moved on to the next sketchbook.

Here are a few of my favourite travelling companions.

"Painting is self-discovery. Every good artist paints what he is." —Jackson Pollock

My new favourite for longer hikes: a leather-bound Moleskin, 3.5 x 5.5 inches.

I like the landscape size - longer in width.

14 x 10 inches, Arches, hardcover, large rings for flipping the cover back or standing it up; 140-pound cold-press paper.

A three-ring binder, 7.5 x 10 inches, is good for road trips. You can cut your favourite watercolour paper to fit, then hole punch. This way you can carry 140- and 300-pound paper and just take a couple of sheets out if you have to walk any distance. You can also pack extra sheets of paper. Finally, it stands up to make an impromptu easel!

Supplies: On-Location Painting

PALETTE: A fold-up palette is good for travelling. They come in sizes as small as 5 x 2 ½ inches – great for long hiking trips when you want to travel light. I have a great palette for trips that is 10 x 5.5 inches; it is light and holds enough paint for larger pictures and longer trips. It is by Alvin and has 18 generous wells, a removable mixing area and seals tightly. Did I mention it's light?

MY BASIC TRAVELLING COLOUR PALETTE:
Primary Magenta (a Maimeri Blu paint) or Permanent
 Rose
French Ultramarine
Burnt Sienna
Perylene Green
Winsor Blue (red shade)
Raw Sienna
New Gamboge
Alizarin Crimson
Cobalt Blue

STOOL: Depending on how far you are hiking, take one of the following stools.

- *Long hikes*: A three-cornered stool is light enough to carry in your pack for a day. Just be careful. One time I was flipped off a dock and landed in swampy water because the leg of the stool slipped through an opening in the boards!

- *Short hikes*: This is my favourite stool. It weighs 2 pounds and has a carry strap and a back support. There are various types in art supply stores and camping stores.

- *Or, my new favourite*: A Thermarest self-inflating cushion. Self-inflates and packs down to fist size! Provides a soft and dry seat anywhere.

For long hikes, where you want to pack light

I carry a small sketchbook, 3.5 x 5.75 inches; a water-soluble pen (Elegant Writer by Speedball); and one or two tubes of watercolour paint – Raw Sienna, New Gamboge, or French Ultramarine; and a #6 round brush. All of this will fit into a small plastic food container bag that when zipped is waterproof.

You'll be amazed by what you can do with a limited number of supplies. For example, you can use your pen to sketch your subject. Then add water and tilt the sketchbook – the colours will separate like magic! Add a touch of yellow or blue to finish.

Opposite: ***Mt. Rundle***, on-location sketch using pen.

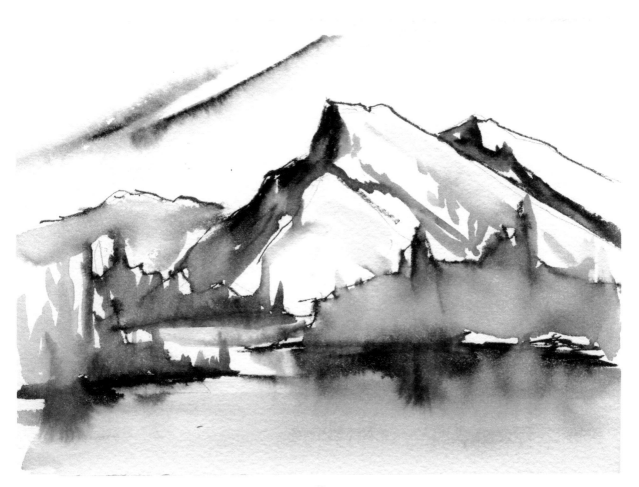

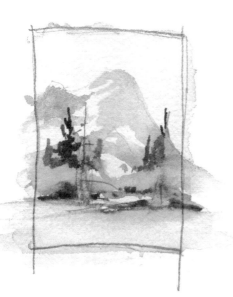

The Beginning

Value and Interest

Before you begin painting you should also have an idea about where your lights and darks and centre of interest will be.

Do a value sketch and limit yourself to five values, as seen here.

Then, do a small – 3-x-4-inch – sketch in black and white. Try to use the five values, and have the darkest dark and the lightest light at your centre of interest.

Circle the centre of interest to make sure it is in the "golden mean" (see Watercolour Words page 74). Let this be your guide when you go on to your painting.

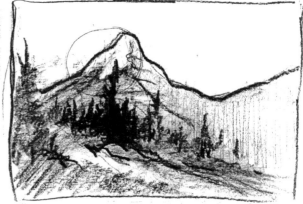

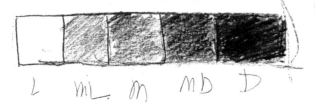

Starts

Before you begin painting you need to know where you're going!

Here are some examples of what I call Quick Starts.
There are only a couple of rules:

- Keep the size small! The ones you see here are 2 x 3 inches.
- Use only three colours, a red, yellow and blue. Decide on the mood you want to create and choose your colours. Perhaps you want to use two different colour palettes and decide which one you like the best.

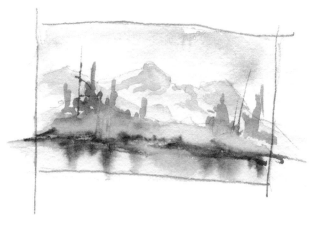

Pen and Ink Sketch

Using two colours – French Ultramarine and Burnt Sienna – you can do a quick pen and ink sketch on location.

First, wet the paper, brush French Ultramarine across the top of the paper, then wash the brush out and pull this colour down with your damp brush to the bottom of the page. You should have a graded wash, darker blue at the top to almost white at the bottom. Go back to your palette right away, fill your brush with Burnt Sienna, and starting at the bottom, brush colour up to the middle of the paper, being careful to blend the edge and overlap with the French Ultramarine.

Let it dry, and then use your ink pen to sketch in your mountain landscape. Use hatchmarks, cross-hatching and heavy and light lines to denote the texture in the trees and mountain.

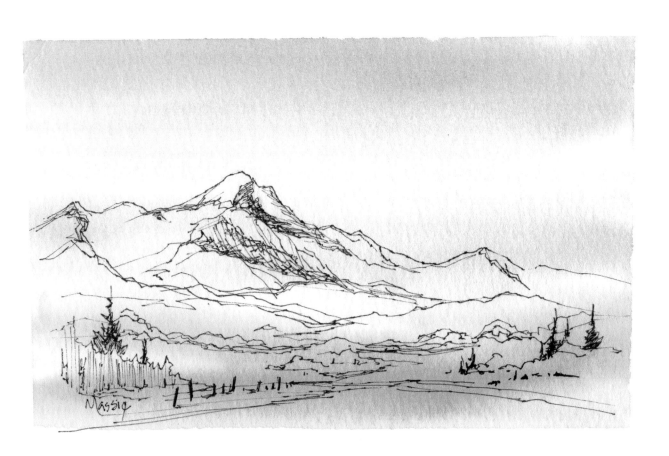

Massig

Finding Your Palette: Colour Schemes

Do four small studies of your subject using these colour schemes.

This is where black and white photocopies of your subject come in handy. They will keep you from thinking about the colour in the photograph and help you be more creative when looking at your picture. They will also help you focus on the values in the subject.

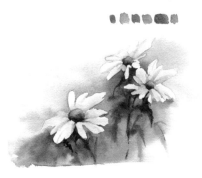

MONOCHROMATIC

This is the simplest, a one-colour colour scheme. The colour can be lightened or darkened in value – at least nine values. Every colour has a value; generally yellow is the lightest-value colour and violet is the darkest. You can lighten the colour with water or darken it by using pure colour or by using the colour's complement.

ANALOGOUS

The analogous colour scheme uses three, closely related, harmonious colours. It is one of the most beautiful colour schemes to work with because you're using colours that are side by side on the colour wheel. Any three adjacent colours can be used: Ultramarine Blue, violet, Cerulean and Emerald Green, or red, red violet and violet (you can use the complement of any of these colours to neutralize the intensity).

COMPLEMENTARY

Two colours directly opposite each other on the colour wheel: reds and greens, blues and oranges, yellows and violets. Remember, you get an infinite variety when you mix from full colour across the colour wheel; this includes all the neutrals in the middle.

Note: *The Principles of Harmony in Contrast of Colours and Their Applications to the Arts*, by chemist Michel Eugène Chevreul (1855) explains the theory of simultaneous contrast. If you stare at a circle coloured a particular hue and placed on a white field and then close your eyes, that colour's complement will appear before your closed eyes. Chevreul's book became a bible for the Impressionists, who employed complementary colours from nature: red rocks with green lichens, yellow and purple flowers, red flowers with green leaves, and so on.

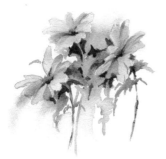

SPLIT COMPLEMENTARY

For this scheme, use three closely related colours with one contrasting colour. For example: 1. Violet, blue violet, blue with yellow orange or, 2. Cobalt Turquoise, Phthalo Green, yellow green with Permanent Rose. Or perhaps, green, blue green, blue with red orange; or even, Cadmium Yellow, Scarlet Lake, Cadmium Red Light, with blue violet.

How to Make a Tree ... a coniferous tree!

They say a picture is worth a thousand words, so look carefully at the tree sketch and the painting presented on this page and the next. Focus on the darks and lights in the sketch; see how they connect as you go up the tree.

Look at the painting and notice the pure yellow colour that mixes and mingles with the green. Look at the branches; they are not even on both sides, and the upper branches are younger, so they have an upward tilt while the lower, or older, branches tend downward. The core of the tree is darker. Of course, there is less light getting to the branches there!

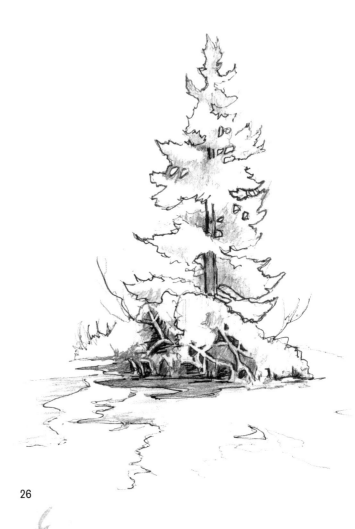

26

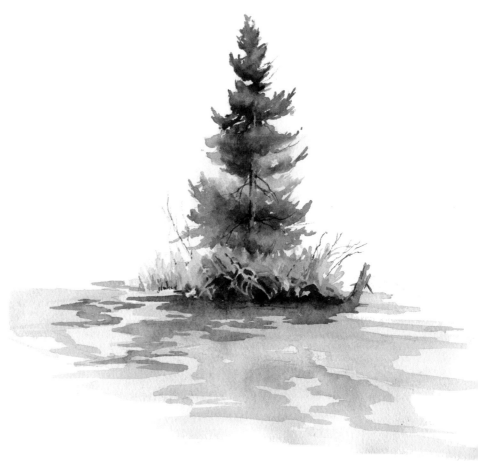

"Concentrate all your
thoughts upon the work
at hand. The sun's rays do
not burn until brought to
a focus."
—Alexander Graham Bell

Sky

"Pure" light sky – Rose Madder, Aureolin and Cobalt Blue

Stormy sky – French Ultramarine, Burnt Sienna and Alizarin Crimson

Hard- and soft-edged clouds

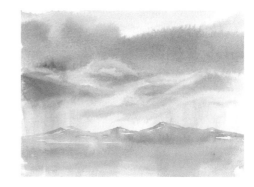

Stormy sky – "Lifted" clouds

Take 30

A Landscape Impression

Once in a while you need to do a painting at one sitting. You might ask, why can't I fiddle around for hours? You can, but you should try doing something from start to finish that might help you focus on the painting. Set a time limit – 30 minutes, 40 minutes, just sit down and do it! Oh, by the way, read over this first because once you start you can't stop. Have a snack, a drink of water, ready? Go!

Step 1

First, make a quick loose sketch on one/eighth of a sheet of watercolour paper, approximately 7½ × 11 inches, showing only where you want the bottom of the trees and the shoreline of the riverbank. Then mix puddles of the colours. Let's keep the palette simple.

Step 2

Next, mix all the colours you will need.
Sky and water – Cobalt
Mountain – Cobalt and a bit of Raw Sienna

Midground trees – Cobalt and Raw Sienna. Mix them together until you get a mid-value green that you like.
Foreground trees – Cobalt and Raw Sienna. Use less water and more paint to make them darker. You'll also use this colour for *reflections* in the water.
Riverbank edge – French Ultramarine and Burnt Sienna (darks, thick paint).

Step 3

Wet the paper on both sides and place it on a piece of Plexiglas or other waterproof surface, making sure that when you lift up the edge, the paper is suctioned back down. There is no masking tape involved.

Step 4

START: With your #6 or #8 round brush, apply Raw Sienna and Burnt Sienna across the foreground riverbank.

Step 5

SKY: Apply Cobalt, beginning at the top of the page all the way down to the top of the ground area. Also,

brush this colour across the water area. Don't stop now!

Step 6

MOUNTAIN: Brush the Mountain shape in with the mixture of Cobalt and Raw Sienna. Keep the brushes moving!

Step 7

MIDGROUND TREES: Use the light value of the colour green, dropping in some pure Raw Sienna and Burnt Sienna at the bottom of the trees – let the colours mix and mingle on the paper.

Step 8

FOREGROUND TREES: Use the darker mixture for the foreground trees. Don't make them the exact size. Leave room for the paint to spread. Tilt the board and paper up and drop in some dark reflections along the edge of the bank and under the foreground trees that you have just painted. Let your brush keep touching the area along the riverbank so they can spread down on the wet paper. If the reflections are not spreading down, it could be that

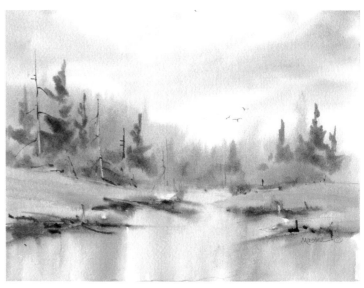

***Dreams of Mountains – as in their sleep they brood on things eternal**, El Tovor Doorway, Grand Canyon*

the paper has dried; you can take your 2-inch brush and go across the water area with a horizontal motion to rewet it. Caution: Make sure you leave some light in the water.

Touch the foreground trees from the middle if you

want to keep them dark, this will let you know how wet the paper still is and will darken the value.

Step 9

RIVERBANK EDGE: Use French Ultramarine and Burnt Sienna to create some of the strongest, darkest values along the riverbank edge. Touch the bottom edge of this colour in the top if you want to make sure that it blends in to the water. You could also scrape with a palette knife to create some texture that will connect the riverbank to the ground.

Step 10

CALLIGRAPHIC STROKES: The last thing you want to add are the calligraphic touches. As the paper should be almost dry now, these will have a hard edge. These strokes will represent the bare tree trunks and the bits of branches and shadows of rocks along the riverbank.

Here is a little bit about one of the greatest Impressionist watercolour painters: J.M.W. Turner was an English painter whose work bears impressive witness to the use of transparency of colour and light. Born in 1775, he died in 1851, leaving nearly 20,000 watercolours and drawings, which he bequeathed to the the nation. He was so involved with nature that he could identify with the elementary forces of wind, fire and water; once he lashed himself to a ship's mast in order to experience a storm at sea. Turner used toned paper to lay down washes of colour using a lot of water; he added details toward the end of his painting process, using a fine brush or pen.

Take 10

Landscape Impressions

If you did Take 30 then you are ready to do a ten-minute painting.

You want to use one-eighth of a sheet of paper. Keep it small and manageable. For example, this image of Lake O'Hara is 11 x 7½ inches.

Mix the colour you will use and keep the palette simple, a red, yellow and blue. Mix them together and change the value to get your greys and dark greens.

Keep the brush moving. Do the sky, move to the water, up to the shadows, then the foreground and midground, the shadows should be dry so add colour for the mountain rock, now to the midground trees … simple!

"I am still learning." —Michelangelo

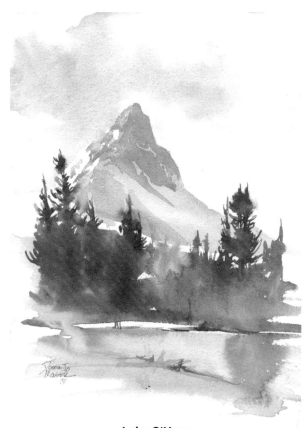

Lake O'Hara

32

Ghost Ranch: Pedernal

This view of Cerro Pedernal is from Ghost Ranch. Use the same colours suggested in the sketch of Arches National Park (see page 34) and include some Burnt Sienna with French Ultramarine for Pedernal (the flat-topped mountain), and some Winsor Blue for the lake.

Georgia O'Keeffe had a ranch here, and a home and studio nearby in Abiquiú. She painted Pedernal many times and said that if she painted it enough, God would give it to her. Her ashes are scattered on this mountain.

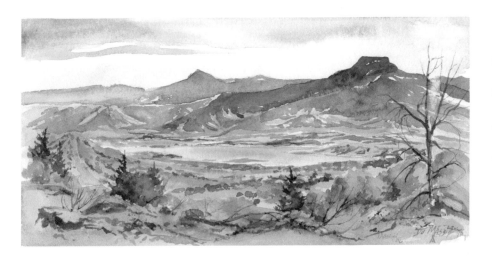

Ghost Ranch, New Mexico

"Art has something to do with the achievement of stillness in the midst of chaos."
—Saul Bellow

33

Arches National Park, Utah

COLOURS: Aureolin, Permanent Rose, Cobalt, New Gamboge, French Ultramarine, Raw Sienna

Step 1

Wet the sky and load your flat brush with French Ultramarine and Cobalt and gently move your brush from left to right, letting the colour flow off the brush and gradually get lighter as it goes toward the horizon.

Step 2

Once the sky is dry, paint the background mountains with a blue-purple mixture of Cobalt and Permanent Rose. In horizontal brushstrokes, using your #8 round brush, overlap the following colours at their edges from the background to the foreground: Raw Sienna, Cobalt mixed with Permanent Rose, and New Gamboge mixed with Cobalt. The edges should blend and mix and mingle.

Step 3

The southwestern colour that you see here in the arch, and in adobes and mountains, is a mixture of Aureolin and Permanent Rose. Do a sample mixture on a scrap piece of paper so you can see how much of each to mix to get this colour. You can add shadows using Cobalt after this colour has been painted on the arch. If you want a stronger shadow, glaze Cobalt on again after the first wash has dried. If you want more local southwest colour, drop in your Aureolin/Permanent Rose mixture while the Cobalt is still damp.

Step 4

The foreground trees are a mixture of New Gamboge and French Ultramarine.

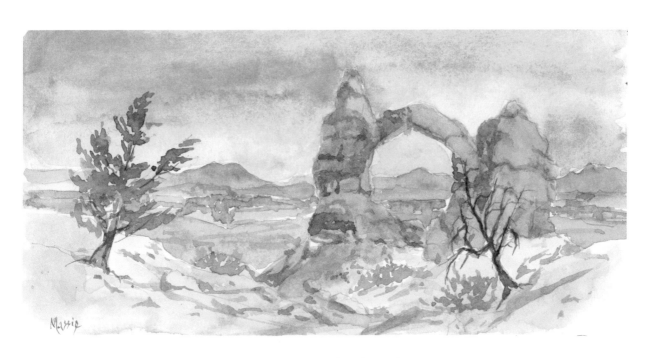

Arches National Park, Utah

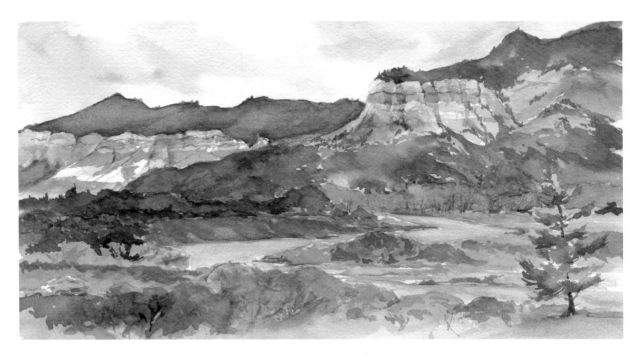

Santa Fe National Forest,
Chama Canyon Wilderness, northwestern New Mexico, 75 miles (121 km) north of Santa Fe

Bison in Yellowstone, Geyser Basin

This picture is both about creating the look of mist and fog, and adding a subject into a landscape. Look at the shape of the bison without details or colour. They have a distinctive silhouette. Use "proportion" and "sighting" to help you get the shape.

COLOURS:

Winsor Green, Burnt Sienna
Trees: Raw Sienna, Burnt Sienna, French Ultramarine

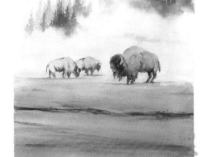

Bison Geyser Basin: Quinicridone Burnt Orange, Winsor Blue, Raw Sienna, Burnt Sienna

Step 1

To create the misty feel in this painting first wet the area where you see the fog with clean water, then immediately paint the trees from the top and let the bottoms disappear into the wet area. Before it is dry, get the paint and the water out of your round brush, push it down in the fog area and turn it in a circular motion to define the edge where the trees meet the fog. You must work quickly! Let it dry.

Step 2

You may want to add darker treetops by glazing over the original trees in certain areas, then soften the bottom where it disappears into the fog with a damp brush. Use a circular motion with your brush again to maintain the rounded look of fog against the trees.

Hidden Lake, Glacier National Park, Montana

The trail begins behind the visitor centre at the summit of Going to the Sun Road, Logan Pass. Round-trip to the overlook is 3 miles (5 km). Look for mountain goats along this hike.

Use Think Shapes (pages 44–45) as a guide when you are doing a quick sketch of a mountain with a lot of exposed rock, as you see in this sketch.

Step 1

First, use French Ultramarine to go over the snow and rock where you see shadows.

Step 2

To simplify the rock in this picture, wet the rock areas separately, using the white snow gullies to divide the sections. Wet each area and drop in some Burnt Sienna, then add some grey/purple – French Ultramarine mixed with Alizarin Crimson – to create the shadows and depth on the mountain face. On the main mountain, move your round brush up and down when adding the grey/purple to indicate the crevices.

Step 3

The colour of high alpine mountain lakes, while different in spring and fall because of the glacial runoff, can be indicated with a Windsor Blue/Winsor Green mixture. When there is sediment in the lake you can use Cobalt Turquoise.

"Only those thoughts that come from walking have any value." — *Friedrich Nietzsche*

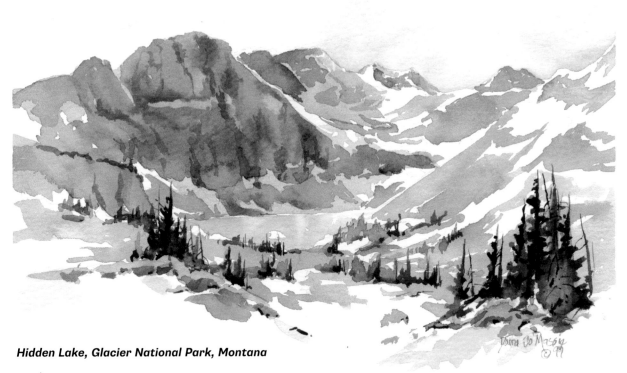

Hidden Lake, Glacier National Park, Montana

The trail begins behind visitor centre, at summit
of Going-to-the-Sun Road, Logan Pass, round
trip to overlook, 3 miles (5 km).

Alaska, Inside Passage

COLOURS: French Ultramarine, Permanent Rose, Aureolin

The West Coast has a lot of humidity and when you are painting this area you want to create that sense of mountains fading into the distance. This is achieved by layering glazes of colour in values from light to dark and allowing the paper to dry in between each glaze of colour. The colours of distant mountains will be more purple and the closer mountains will become more distinct, darker in value and bluer.

Step 1

Using your ¾-inch flat brush, wet the paper from top to bottom and immediately brush the middle of the paper with Aureolin, then brush Permanent Rose at the top edge of the Aureolin, and finally brush French Ultramarine that you have mixed with a bit of Permanent Rose, and Aureolin to grey it, across the top and the bottom of the paper, blending it into the pink. Let it dry.

Step 2

Add water to your mixture of the greyed French Ultramarine for the backmost mountain; use your round brush and make a hard edge against the sky, continuing to move down the mountain until you get to the bottom of the trees. Watch that the top edge of the mountain doesn't become regular round shapes – in other words, you don't want it to look like a pumpkin patch! It has to have some irregular peaks and valleys. Let it dry.

Step 3

Use the same method for the next two layers of mountains, gradually adding more blue to create a darker value. Let each mountain range dry completely before you begin the next overlapping one. With the closest mountain, you can leave some snow gullies by simply not applying paint in certain areas. This is negative space painting – you are making the snow on the mountain appear by painting around the edge of

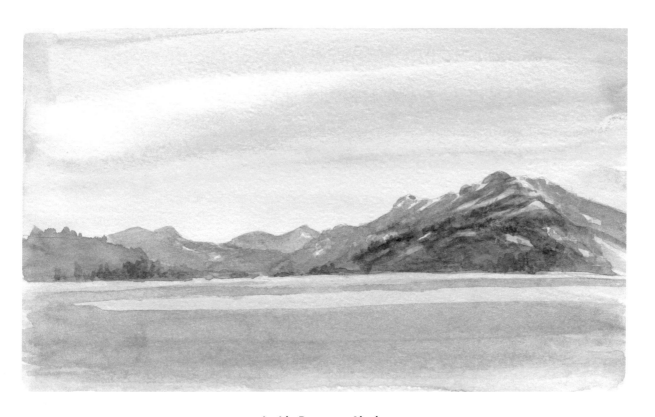

Inside Passage, Alaska

it. You can use your pencil to lightly draw in the snow gullies, which will give you practice in painting and seeing negative space

Step 4

Mix some Aureolin with the French Ultramarine to create a grey/green for the foreground trees. Bring this colour down to the water's edge. On the right-hand mountain, you can use your clean, damp brush to pull the edge of some of the green up into the mountain slope.

"People ought to saunter in the mountains – not hike! ...Away back in the Middle Ages people used to go on pilgrimages to the Holy Land, and when people in the villages through which they passed asked where they were going, they would reply 'A la sainte terre,' 'To the Holy Land.' And so it became known as sainte-terre-ers, or saunterers. Now these mountains are our Holy Land, and we ought to saunter..." —John Muir

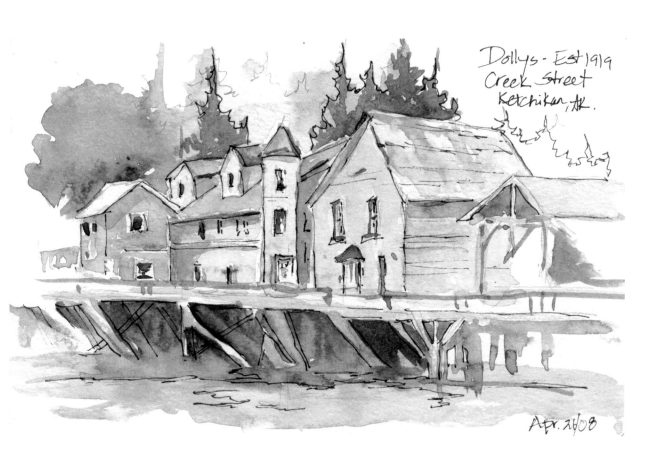

Dollys - Est 1919
Creek Street
Ketchikan, AK.

Apr. 26/08

Think Shapes

When painting a complex subject like this try to see the subject as a group of simple shapes

- sky + peaks
- distant hills
- water, stream, lake
- foreground

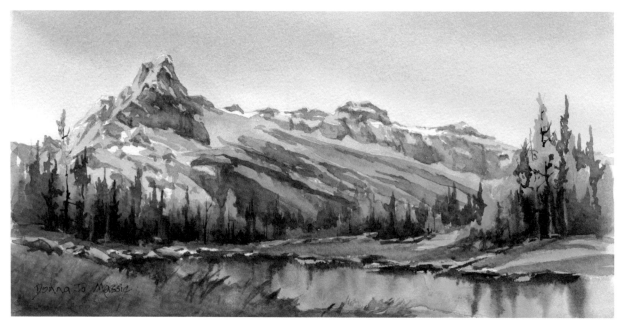

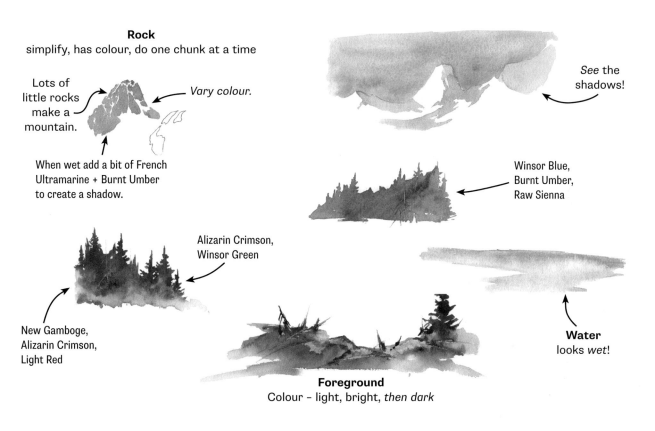

Rock

simplify, has colour, do one chunk at a time

Lots of little rocks make a mountain.

Vary colour.

When wet add a bit of French Ultramarine + Burnt Umber to create a shadow.

See the shadows!

Winsor Blue, Burnt Umber, Raw Sienna

Alizarin Crimson, Winsor Green

New Gamboge, Alizarin Crimson, Light Red

Water
looks *wet!*

Foreground
Colour – light, bright, *then dark*

It's like cutting these shapes from coloured paper!

Green, Green Everywhere

In the mountain landscape greens are very important. Green can be warm or cool – dark or light – the variety is exciting. Let's explore some colours you can mix together for all those greens in the landscape.

Mixing blues, yellows and reds

Cobalt Blue	more Rose Madder	more Aureolin Yellow

You can paint a picture using greens only

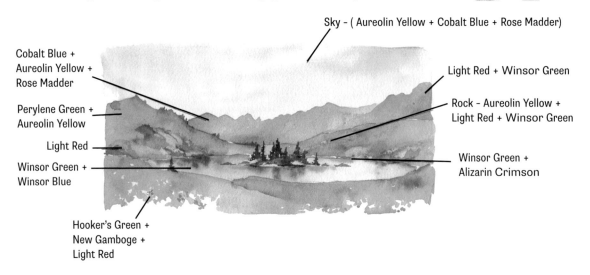

Sky - (Aureolin Yellow + Cobalt Blue + Rose Madder)

Cobalt Blue + Aureolin Yellow + Rose Madder

Perylene Green + Aureolin Yellow

Light Red

Winsor Green + Winsor Blue

Hooker's Green + New Gamboge + Light Red

Light Red + Winsor Green

Rock - Aureolin Yellow + Light Red + Winsor Green

Winsor Green + Alizarin Crimson

Trees

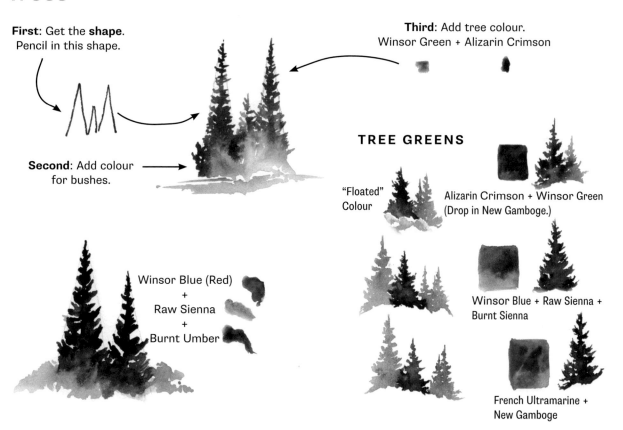

First: Get the **shape**.
Pencil in this shape.

Second: Add colour
for bushes.

Third: Add tree colour.
Winsor Green + Alizarin Crimson

TREE GREENS

"Floated"
Colour

Alizarin Crimson + Winsor Green
(Drop in New Gamboge.)

Winsor Blue + Raw Sienna +
Burnt Sienna

French Ultramarine +
New Gamboge

Winsor Blue (Red)
+
Raw Sienna
+
Burnt Umber

Poplar Trees

Step 1

Make a light sketch of the trees and leaves with an H pencil.

Step 2

Mix puddles: Grey/blue: French Ultramarine, Burnt Sienna, Alizarin Crimson; yellow: New Gamboge; green: French Ultramarine and New Gamboge. The colours should be a light value.

Step 3

Wet all of the paper, and using your big flat brush, separately pick up each of the colours, putting them in the areas where you see yellow (the leaves), blue/grey (on some of the edges of the paper and trunks), green (also in some of the leafy areas). Note that the colours will spread the width of your brush. This is okay because it will give your background perspective when you put in the definite shapes of the trunks and leaves. The colours should mix and mingle at the edges. Let the paper dry.

Step 4

Tree trunks: Mix French Ultramarine with a bit of Alizarin Crimson and Burnt Sienna. Load your #8 round brush with this colour and paint down the left side of the tree trunk, going around any leaves with a hard edge. As soon as you finish this section, clean your brush, get all the paint and water off, and then immediately push the brush hairs flat down along the edge of the shadow, slowly so that you get a soft, rounded shape as the colour is pulled into the water laid down by the brush. Don't go back!

Step 5

Tree bark: French Ultramarine and Burnt Sienna. Mix the two colours in a dark value, and then use your round brush to pick up this colour and put it full strength on the areas where you see branches connected to tree trunks and to the knot holes. Do this one

area at a time. After the dark is applied, wash your brush out, removing the water. Touch one edge of this dark, pulling it in a vertical direction, up or down, along the branches and tree trunks. You can go back later and make some of these areas darker.

Step 6

Leaves: New Gamboge, Alizarin Crimson, Burnt Sienna or Quinacridone Burnt Orange. Draw the veins of the leaves before you begin painting. Glaze the leaves with a light-value wash of these colours. Let them mix and mingle on the paper. Let it dry. Take a deeper value and paint around the outside of the pencil marks, leaving the light where the veins will be. For the negative-space leaves, paint *behind* where you see the edge of the leaf, and wash out the edge until it disappears. Go around the leaves in the painting, gradually adding more colour to make more negative-space veins or leaves.

Step 7

Take your rigger and add in a few thin branches to finish the painting.

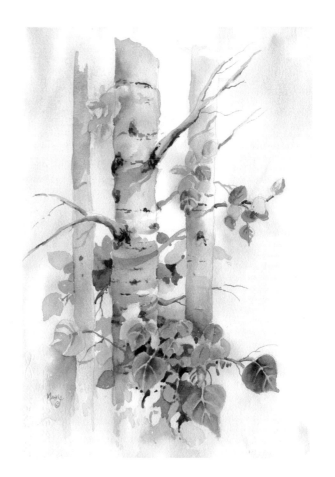

Lake Agnes Teahouse

Step 1

Mountains: Mix two puddles of French Ultramarine and Alizarin Crimson. One puddle will have more Alizarin Crimson than the other: this will be the distant mountain. Watch the value – use mid-values for the distant mountains and a slightly darker value for the closer mountain. Tilt your board to about a 30° or 15° angle, take the puddle that has more Alizarin Crimson in it and load your round brush with the paint. Push the paint hairs all the way down to the ferrule (the metal part of the brush) and go right along the edge of the top of the distant mountain. As soon as you get to the other side, flip the brush and go right over the bottom edge of the colour that you just painted. The top of the brush will be pointing to your left going one way, then you will flip and point the top of the brush to the right on the way back (if you are right-handed). Lift your brush up, rinse it in water and touch it on a sponge or towel to get the excess water off, and then go right over the bottom edge of the paint, down to where the mountain joins the lake. You should have a great wash, smooth, with graded values from the top of the mountain down to the lake. Let it dry.

Step 2

Paint in the silhouette of the second mountains the same way. Use paint from the puddle with less Alizarin Crimson and more blue.

Step 3

Trees: Look at the trees as a shape. Wet the entire tree area and drop in some light colours first: New Gamboge, Burnt Sienna or Raw Sienna. Immediately come back in with some dark greens (French Ultramarine plus New Gamboge, Burnt Sienna) and, starting at the tops of the trees, bring some of this colour into the lights. Let them mix and mingle on the paper. As the paper starts to dry, add more of the dark greens to certain areas to create a feeling of depth. Darker values will appear to be closer to the viewer while lighter/blue colours will appear to be more distant.

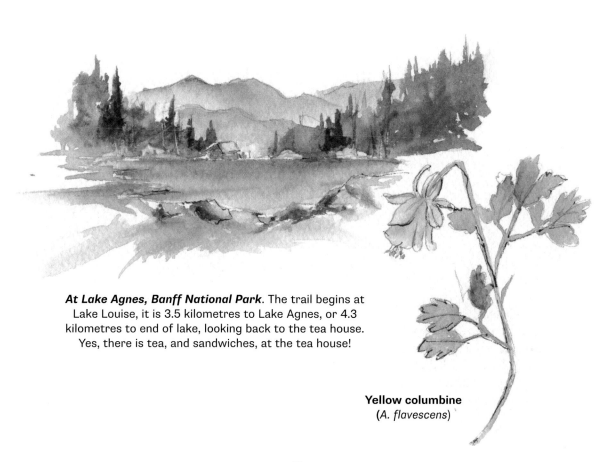

At Lake Agnes, Banff National Park. The trail begins at Lake Louise, it is 3.5 kilometres to Lake Agnes, or 4.3 kilometres to end of lake, looking back to the tea house. Yes, there is tea, and sandwiches, at the tea house!

Yellow columbine
(*A. flavescens*)

Step 4

Lake: Mix Winsor Blue and Winsor Green together carefully as these staining colours are difficult to remove from paper or clothing! Next, wet the entire area that is the lake, load your round brush with the colour you just mixed and starting at the top of the lake push the brush from side to side, gradually going down to the bottom. Overlap your brushstrokes; because you have wet the lake area you should be able to go from the top to the bottom and create one smooth wash. There will be variations of light and dark, but this makes it look like a natural lake. Make sure you go in horizontal strokes all the way from one side to the other.

Step 5

Rocks: Place a mixture of pure Burnt Sienna and French Ultramarine at the bottom of each of the rocks. Clean the brush, removing excess water so that it is just a damp brush... immediately run your brush over the top edge of the paint. This pulls the dark colour up into the top of the rock. To lighten the area at the top of the rock, lift light off some of the paint while it is still wet with a clean damp brush.

Step 6

Grass: Use French Ultramarine and New Gamboge mixed together and paint in the grass under the rocks and along the shores edge. You can create a Vignette by leaving interesting white spaces at the edge of the painting.

Twin Flower

COLOURS: Permanent Rose or Quinacridone Rose, New Gamboge, French Ultramarine, Raw Sienna

TOOLS: Waterproof ink pen

Step 1

Sketch your subject with a pencil, and then go over it with your waterproof ink pen.

Step 2

Add light washes of pink to the bottom of the twin flower. Clean your brush and touch the edge of the colour, then push down and pull it up toward the stem. This will create a value change from dark pink to very pale, almost white.

Step 3

Wet the leaf areas one at a time, then drop in various amounts Raw Sienna and green (a mixture of New Gamboge and French Ultramarine). Let the colours mix and mingle on the leaves to create a value change that happen naturally when light hits the different parts of the leaves.

"The challenge is in the moment; the time is always now." —James Baldwin

July 1/95
Many Springs,
Bow Valley Provincial Park...
The most incredible
profusion of flowers I have
ever seen! - everything is
blooming - We went in the
morning + water droplets
decorated the wild rose
leaves. Found the endangered
white ladies slipper, also in
bloom: elephant head wood lily
 Indian paint brush
 Twining honeysuckle
 yellow ladies slipper pine drops
 butterwort
 shooting star pink wintergreen

Boyd enjoyed photographing
all these flowers in one
place, and the swirling
waters of these springs...

DJM

Wood Lily

COLOURS: New Gamboge, Permanent Rose or Quinacridone Rose, French Ultramarine

TOOLS: Waterproof ink pen and a #6 round brush

Step 1

Another subject to sketch with your pencil, and then go over it with a waterproof ink pen.

Step 2

Mix New Gamboge and Permanent Rose to create a vibrant orange.

Step 3

Wet each petal and then drop in some of the orange at the center with your round brush, then pull some of the colour out to the edge making sure that you leave a value change. You should see darker orange at the center and lighter at the outside tip of the petal. Do each petal one at a time.

Step 4

When you have finished the petals, paint the leaves and stem using a variety of greens that you have created with French Ultramarine and New Gamboge. Work on each leaf, one at a time. You can also drop in some pure New Gamboge on the edge of the leaves to create light and dark areas. Do the stem using the same method, dropping in light and dark greens.

Step 5

Add the stamen and pistils to the center of the flower using a rigger with a dark colour.

Step 6

Finally, add a few wisps of grass at the bottom... try not to bunch them together, but rather concentrate on making one longer, one shorter, have one cross over another one... you want to make it feel natural and organic.

Rocks

The colour of rocks varies from warms in the south-west to grey/blues in the Canadian Rockies.

Start with pure paint: French Ultramarine and Burnt Sienna – put it on thick, more paint at one of the edges at the bottom of the rock.

Layer one colour over the other.

Take your round, damp brush and push it down on the edge of the paint. Continue to the top of the rock with clean water. You can now use your brush to pull some colour out, or spatter for texture.

Mountain Waterfall

Notice the composition: it is a vignette, where interesting white spaces are left at the edge of the painting.

COLOURS: Winsor Blue, French Ultramarine, Cobalt, Burnt Sienna, New Gamboge, Alizarin Crimson, Raw Sienna, Perylene Green

Step 1

Water: Wet the waterfall area and load your round brush with a light value of one or more of the blues: Cobalt, Winsor Blue, French Ultramarine. Paint in the direction the water is going. Leave white foam areas – you will apply a darker blue above the foam. Let it dry.

Step 2

Rocks: See page 56 for sample rock. When painting rocks, always think dark against light. Apply pure, thick Burnt Sienna and French Ultramarine (maybe a touch of Alizarin Crimson) to the bottom half of the rock. Avoid straight lines here – think thicker at one edge, thinner at the other edge of the rock's bottom. Immediately run a clean, damp brush along the edge of the colour, and brush again to the top of the rock. You should have dark at the bottom of the rock and light at the top. Using this technique, go back in and add more paint at the bottom of the rock and watch it spread out into the water at the top, or take a damp brush and run it along the top of the rock to lift excess paint. The crevice dark should be at the bottom of the rock where it touches the light at the rock in front.

Step 3

Grass: French Ultramarine and New Gamboge, or Perylene Green and New Gamboge, Raw Sienna and French Ultramarine.

Using the colour below the trees and along the tops of the rocks, drop in darker colour along the top edge of the rocks. Create a vignette edge at the sides of the paper.

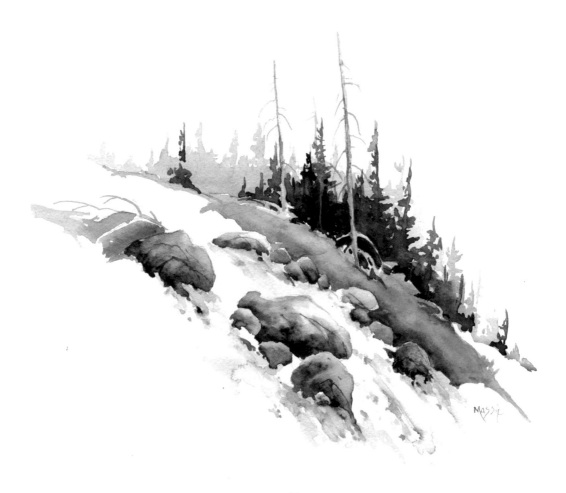

Step 4

Background Trees: Use the same greens as the grass but add more blue for the distant trees and more paint for the closer trees. Paint the background trees first; they are more bluish-green, pale and have less detail than the closer trees. Allow this to dry and then add a second layer of pale but more greenish distant trees. These will appear closer and create depth. Vary the shape and edge of the trees.

Step 5

Dark Trees: These trees are the closest ones and will be the darkest in value. Paint around the tree trunks to create lighter areas and spaces in the dark green for the birds to fly through! For the darks use: Winsor Blue and Burnt Sienna, French Ultramarine and New Gamboge, or Perylene Green with touches of New Gamboge and Burnt Sienna.

Step 6

Water: Add a second layer of blue to the water just above the white foam. Quickly, clean your brush, use a towel to remove all the water, then push it down at the top of the colour and pull *upstream* until it disappears into white. The brush will be damp, not dripping wet!

Step 7

Rigger the tree branches.

Mountain Lake

Step 1

Sky: Wet the sky area, going carefully along the edge of the mountain. Use your round brush with a light value of Permanent Rose, and touch this at the edge of the mountain. When it hits the wet paper it will spread out and up. Load a ¾-inch flat brush with a mixture of Winsor Blue and French Ultramarine. Brush, with the flat edge, at the top of the sky and use the brush to gently encourage the dark areas to flow down. Leave some white spaces! Tilt the board to encourage movement in the sky.

Step 2

Mountain shadows: Mix Burnt Sienna and French Ultramarine for the rock shapes. Add water to this mixture to create the light value that you see where the sun is hitting the mountain. Add more paint to create a dark value for the rock on the side of the mountain that is in shadow. Leave lights for the snow gullies.

Step 3

Background slopes: Mix French Ultramarine and a smaller amount of New Gamboge to create a blue-green. Using the ¾-inch flat brush, in the midground area where the trees make the shoreline, brush the colour over the back slopes and then bring it down into this damp area to create an illusion of softness.

Step 4

Midground forest: You might want to dampen the entire tree area first to get a mixture of values. Then glaze New Gamboge over the tree area for the bright yellows, and add Burnt Sienna at the bottom. When this has lost its shine, add dark green for the trees, allowing some of the yellow and Sienna to show.

Step 5

Water reflections: Mix colours first – separate puddles of yellow, Winsor Blue and dark green. Wet the paper and tilt the top of the board up. Right away, drop in

Winsor Blue first at the edge of the shoreline. Tap the loaded brush on the paper until you get the value you want. Next, drop in yellow, and dark green last. Leave white spaces and don't mix colours with your brush on the paper. Let them mix and mingle on the paper!

Step 6

Finish with the grass: Raw Sienna and Alizarin Crimson. Use thick Burnt Sienna and French Ultramarine for the rocks – scrape with a palette knife to create highlights.

Step 7

Foreground trees: Wet one tree at a time, and drop in New Gamboge on one side. Then add dark greens, letting the two mix and mingle on the paper. Add final rigger details for branches, and lift some lights out with a damp flat brush for the trunks.

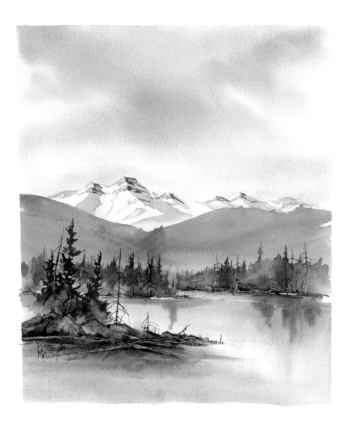

Pine Grosbeak (*Pinicola enucleator*)

The pine grosbeak is nearly the size of a robin and can be found from Alaska across the boreal forests of Canada, south to California, Arizona and New Mexico.

COLOURS: *Bird*: Scarlet Lake or Vermillion, Alizarin Crimson, Paynes Grey, White Gouache; *leaves and branches*: French Ultramarine, New Gamboge, Burnt Sienna; *berries*: Scarlet Lake or Vermillion, Alizarin Crimson

Step 1

Bird: Mix Scarlet Lake or Vermillion with Alizarin Crimson; mix Paynes Grey with White Gouache for a light grey. Starting at the head of the bird, load your brush with the red and pull it down just to the outside edge of the wings, eye and beak. If you want a richer red, let this dry and then apply another glaze of red.

Step 2

Paint the grey under the eye and wing, using your damp brush to feather out the edge of the grey where it meets the red on the underside of the bird and beneath its eye.

Step 3

Use pure Paynes Grey for the beak and eye, but leave a white dot at the front of the eye. Paint the wings black, being careful to leave the white flashes.

Step 4

Wet the branch and drop in green and Burnt Sienna (French Ultramarine plus New Gamboge for green). When this has dried, apply a darker brown – French Ultramarine plus Burnt Sienna – at the bottom of the branch and wet the top edge with a clean damp brush to create a rounded effect.

Step 5

Berries: Wet and drop in Alizarin Crimson and Scarlet Lake on one side. Using your clean, damp round brush, push in a circular motion to lift some colour

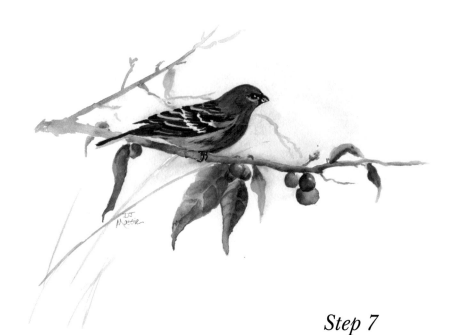

Step 6

Leaves: Wet and drop in New Gamboge and Burnt Sienna in varying amounts. Use an H pencil to draw the veins in the leaves. Mix the two colours together and paint between the veins. The actual vein down the middle and out to the side should be the lighter colour that you first applied. Use a lighter mixture for background branches and leaves.

Step 7

Use gouache for highlights on the head and chest if necessary. Use Paynes Grey for the feet, making sure they go in a rounded backward C to create the roundness of the branch. Ta-da – done! Of course, you can always go back if you want to add in any tiny details.

off one side of the berry. You may need to glaze this again and repeat the same process to get a deeper, richer colour.

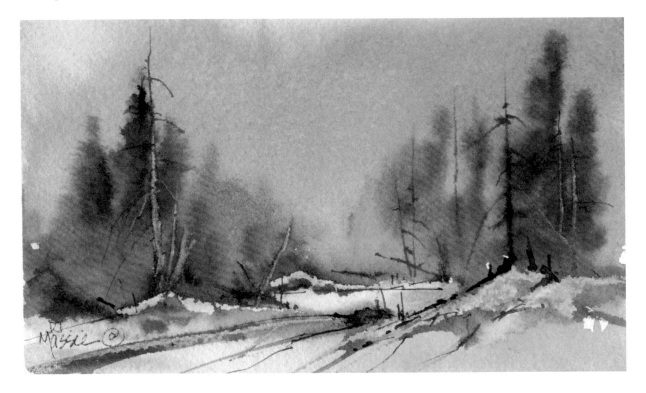

Evening Light, 4 x 6.5 inches

Rancho de Taos, Taos, New Mexico, 7.5 x 11 inches

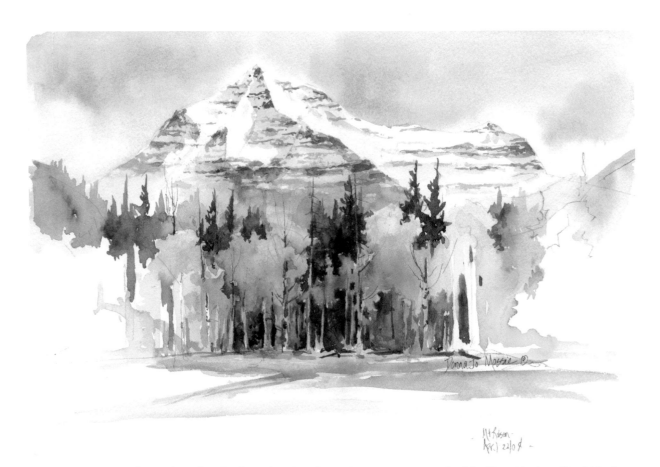

Mt Robson
Apr.) 22/0 8

This page: **Mt. Robson**, Canadian Rockies, 9 x 13 inches Opposite: **Acoma Pueblo**, New Mexico, 10 x 14 inches

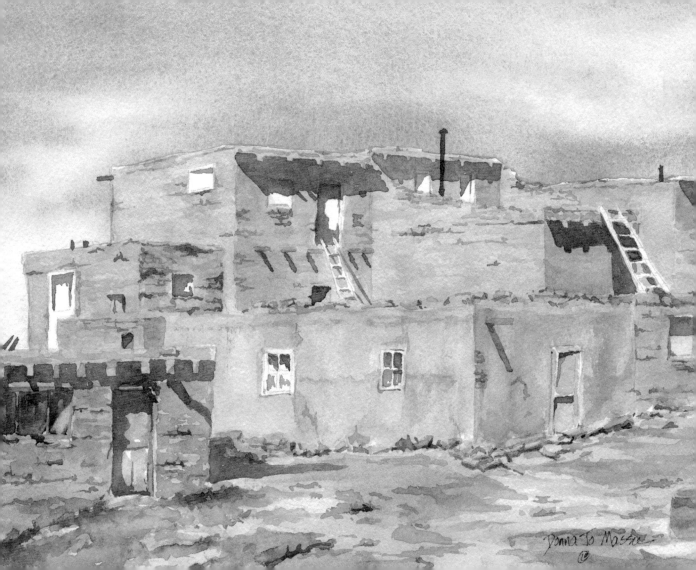

Donna Jo Massie

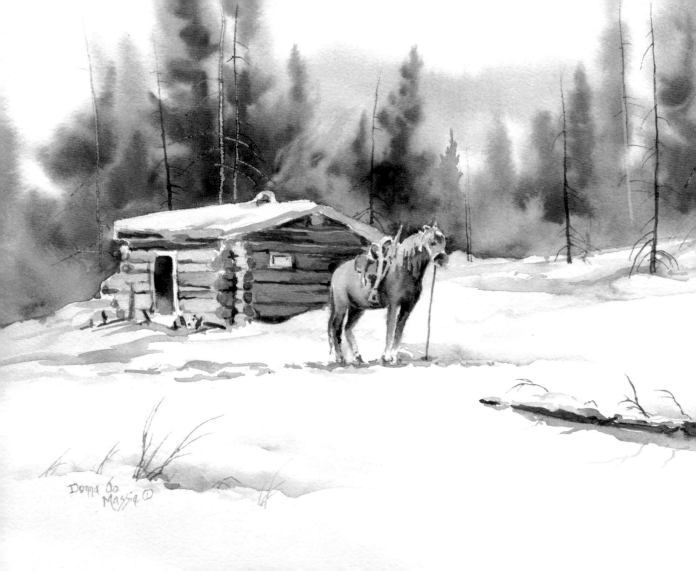

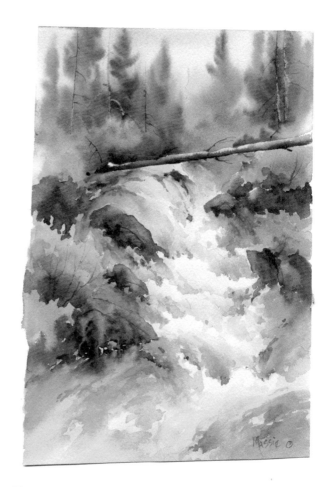

Opposite: ***Bill Peyto's Cabin***,
Canadian Rockies, 9 x 11 inches

Right: ***Avalanche Creek***

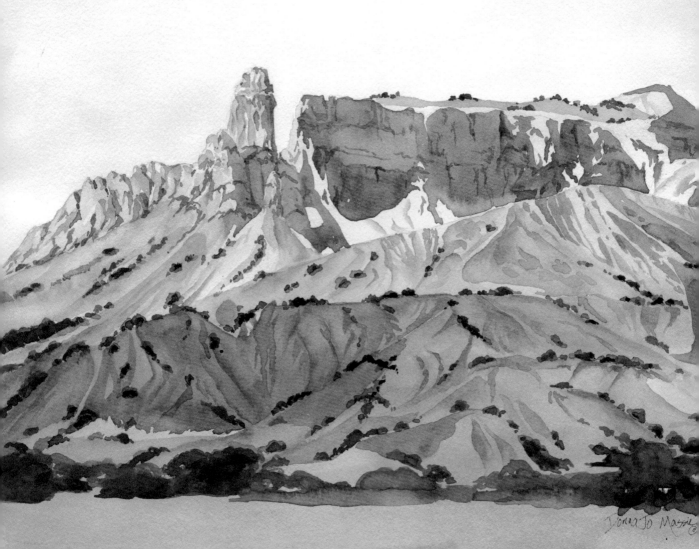

Donna Jo Massie

Opposite: ***Ghost Ranch***, New Mexico, 13.5 x 15 inches
This page: ***Mendenhall Glacier***, Juneau, Alaska, 4.5 x 7.5 inches

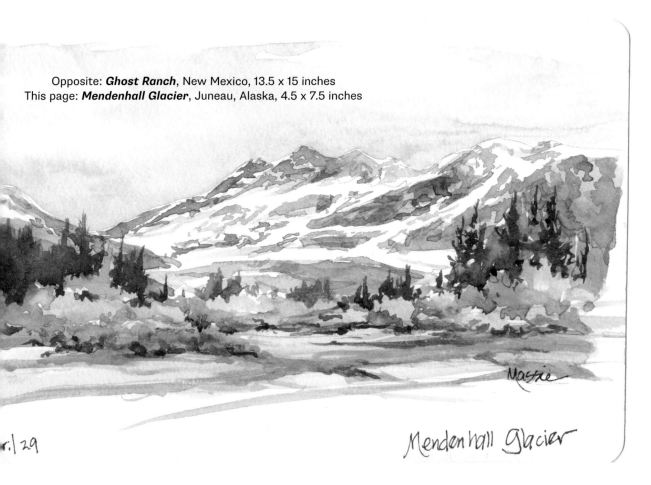

r.| 29

Mendenhall Glacier

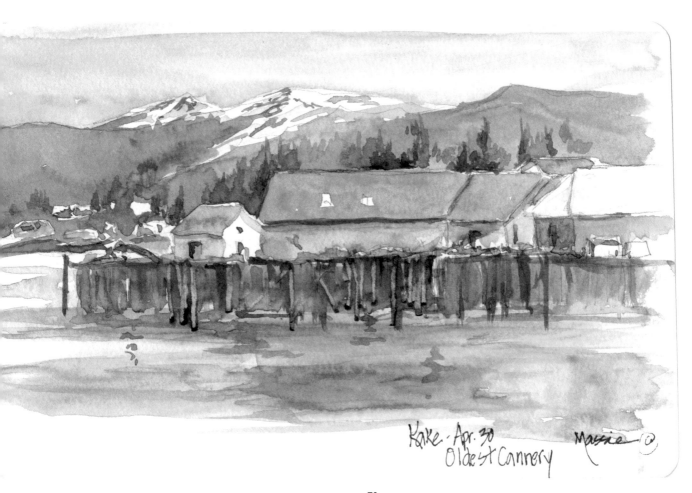

Kake. Apr. 30
Oldest Cannery

Massie ©

Opposite: ***Kake, Alaska***, Inside Passage, Alaska,
4.5 x 8 inches

This page: ***Tongass and Annette Mountains***,
Inside Passage, Alaska, 4 x 8 inches

Tongass Mtn. - Annette Mtn. 4/24

Watercolour Words

BACK RUN (OR FLOWER): The effect you get when you drop clear water into saturated colour that has just lost its shine. Makes great bushes or blossoms.

BOTANICAL PAINTING: Painting studies of flowers, plants, trees and fruits from a scientific point of view.

CHIAROSCURO: The art of painting light within shadows to allow the forms of the object to show even when in intense shade. Rembrandt was one of the great masters of chiaroscuro.

COMPLEMENTARY COLOURS: On a colour wheel, directly across from each colour is its complement. Complementary colours placed next to each other create a "vibration" — the maximum contrast.

CREVICE DARK: Where a form touches the ground. For example, where a chair leg touches the floor, is darker than the shadow that is cast.

FERRULE: On a paintbrush, the metal part that surrounds and holds the hairs.

FLAT WASH: After mixing a puddle of colour, dip your brush into the colour and draw it across the top of your paper. Your paper should be tilted so the paint runs down. Add more paint as you slightly overlap each brushstroke to the bottom of the paper.

GLAZE: A colour layered over another colour, which changes the latter.

GOLDEN MEAN (OR GOLDEN SECTION): The Roman architect Vitruvius determined the ideal placement of a line or point, aesthetically, within a given space. Vitruvius found a numerical relationship, equal to 1.618, between the smaller and larger parts of a space. Simply, an area can be divided into thirds and the intersecting points are where your centre of interest should be placed.

GOUACHE: An opaque watercolour. It can be mixed with watercolours to create tints, however, wash brushes out thoroughly so it won't contaminate your paints and make them milky. Only squeeze out as much as you're going to use as it dries out quickly and cannot be re-wetted successfully for reuse.

GRADED WASH: When you draw the brush across the paper loaded with colour and, as you paint you add more clear water until you are painting with clear water at the bottom. You can't go back to the top!

MASKING FLUID (MISKIT): A latex gum used in painting to protect white areas. These areas may then be painted over. When the paint has dried, you can rub off the Miskit with masking tape or a Miskit eraser. Rub an old brush over a bar of soap, or push around in dish soap before using it with Miskit, then rinse in hot water in order to reuse the brush.

MONOCHROMATIC: A painting is monochromatic when it has been painted only in values of one colour. Burnt Umber, French Ultramarine or Sepia are all good colours for a monochromatic painting. Painting monochromatically is an excellent way to learn about value.

PERSPECTIVE: The effects of distance on the appearance of size, forms and colour. Aerial perspective represents depth by the use of colour, shading and contrast.

PLEIN AIR: The practice of painting outside on location.

POSITIVE AND NEGATIVE SPACE: When you paint the object, you are painting positive space. When you paint behind the object, you are painting negative space.

PRIMARY COLOURS: Basic colours of the spectrum — red, yellow, blue. These colours can't be mixed from other colours.

SECONDARY COLOURS: Orange, green and violet can be mixed from the primary colours, so they are called secondary colours.

SKETCH: A freehand drawing, done without rulers, compasses or other instruments.

VALUE: The lightness or darkness of a colour.

VIGNETTE: A subject painted in a well-designed area of white space. Ed Whitney, *Complete Guide to Watercolor Painting*, has some rules for this:
1. The painted area should touch the edge of the paper in three places.
2. 30 to 40 per cent of the picture should remain white paper, and,
3. You should design the white space with as much care as you design the painted area.

WASH: Laying watercolour paint on paper.

WET-DRY: A technique in which the artist paints with wet paint on dry paper.

WET-WET: A technique in which the artist paints on paper that has been previously dampened and is still wet. The result is a diffusion of forms and colours.

Locations

ALASKA MARINE FERRY

www.ferryalaska.com, 1-800-642-0066
www.dot.state.ak.us
It's the way the locals travel! Rooms with bunk beds, bathroom and large windows available, and the cafeteria food is fresh and great. Sit up front and paint as the scenery goes by slowly.

BANFF, YOHO, KOOTENAY, AND JASPER NATIONAL PARKS, CANADA

www.pc.gc.ca
Excellent websites with updated trails, weather, road reports and more.

GLACIER NATIONAL PARK, MONTANA

www.nps.gov/glac/index.htm
I was artist in residence here for two weeks. The Going-to-the-Sun Road is challenging if you don't like heights, however, Hidden Lake Trail begins at the visitor center, which is at the top of the road. Mountain goats are frequently sighted.

ARCHES NATIONAL PARK

www.nps.gov/arch, 1-435-719-2299

CHRIST IN THE DESERT MONASTERY, ABIQUIÚ, NEW MEXICO

christdesert.org
The monastery sits in the Chama Wilderness across from the Ghost Ranch, 75 miles (121 km) north from Santa Fe on Forest Service Road 151. It is a gravel road, with sections of dirt and clay that are slippery when wet; a four-wheel drive is suggested.

YELLOWSTONE NATIONAL PARK

www.nps.gov/yell/index.htm, 1-307-344-7381
The geyser basins are filled with a multitude of colours, but keep your distance from the bison. They roam the park freely and have been known to charge tourists and automobiles!

Suggested Books

FOR THE BEGINNER

Albert, Greg, and Rachel Wolf. *Basic Watercolor Techniques*. Cincinnati: North Light Books, 1991.

Biggs, Bud, and Lois Marshall. *Watercolor Workbook*. Cincinnati: North Light Books, 1978.

Couch, Tony. *Watercolor: You Can Do It!* Cincinnati: North Light Books, 1987.

Harrison, Hazel. *Watercolor School*. New York: Reader's Digest Association Inc., 1993.

Johnson, Cathy. *Creating Textures in Watercolor*. Cincinnati: North Light Books, 1992.

Page, Hilary. *Watercolor Right from the Start*. New York: Watson-Guptill Publications, 1992.

Parramon, José M. *The Big Book of Watercolor Painting*. New York: Watson-Guptill Publications, 1985.

Szabo, Zoltan. *Painting Little Landscapes*. New York: Watson-Guptill Publications, 1991.

Walsh, Janet. *Watercolor Made Easy*. New York: Watson-Guptill Publications, 1994.

FOR INTERMEDIATE OR ADVANCED PAINTERS

Dobie, Jeanne. *Making Color Sing*. New York: Watson-Guptill Publications, 1986.

Hill, Tom. *The Watercolorist's Complete Guide to Color*. Cincinnati: North Light Books, 1992.

Lawrence, William B. *Painting Light and Shadow in Watercolor*. Cincinnati: North Light Books, 1994.

Ransom, Ron. *Learn Watercolor the Edgar Whitney Way*. Cincinnati: North Light Books, 1994.

Reid, Charles. *Painting What You Want to See*. New York: Watson-Guptill Publications, 1987.

Simandle, Marilyn. *Capturing Light in Watercolor*. Cincinnati: North Light Books, 1997.

Stine, Al. *Watercolor Painting Smart*. Cincinnati: North Light Books, 1990.

Wagner, Judi, and Tony Van Hasselt. *Painting with the White of Your Paper*. Cincinnati: North Light Books, 1994.

BOOKS FOR IMPROVING YOUR DRAWING SKILLS

Albert, Greg. *Drawing: You Can Do It!* Cincinnati: North Light Books, 1992.

Dodson, Bert. *Keys to Drawing*. Cincinnati: North Light Books, 1985.

Edwards, Betty. *Drawing on the Right Side of the Brain*. Boston: Houghton Mifflin Co., 1979.

Hamm, Jack. *Drawing Scenery: Landscapes and Seascapes*. New York: Perigee Books, 1972.

ART BOOKS OF INTEREST

Cameron, Julia. *The Artist's Way: A Spiritual Path to Higher Creativity*. New York: Putnam Publishing Group, 1992.

Flack, Audrey. *Art and Soul*. New York: Penguin Books, 1986.

Henri, Robert. *The Art Spirit*. New York: Harper & Row, 1923. (A classic that every artist should own.)

Ueland, Brenda. *If You Want to Write*. Saint Paul: Graywolf Press, 1987.

DONNA JO MASSIE hails from Cherokee, North Carolina, in the Great Smoky Mountains. She attended Auburn University and taught in Alabama and Florida before moving to Alberta in 1976 as Environmental Educator for Kananaskis Country. She makes frequent sketching trips into the mountains, as well as teaching popular adult watercolour classes and corporate backcountry workshops. She has been Artist in Residence at The Banff Centre and at the Columbia Icefields, and was International Peace Park Artist in Residence for Glacier National Park in the United States. Her work has been exhibited internationally and can be found in private collections around the world. Donna Jo is a member of the Alberta Society of Artists, the Society of Canadian Artists and the Elmore County (Alabama) Art Guild and is an Honorary Member of the Canmore Art Guild. She currently operates a home studio in Canmore, Alberta.